I AM SEA GLASS

A Collection of Poetic Pieces
By
Richard Morgan

WATERCOLORS
By
Pat Morgan

Peace and Poetry
Richard Morgan
P. Morgan

AuthorHouse™
1663 Liberty Drive
Bloomington, IN 47403
www.authorhouse.com
Phone: 1-800-839-8640

First published by AuthorHouse 3/18/2011

ISBN: 978-1-4567-5581-2 (sc)

Library of Congress Control Number: 2011904507

Printed in the United States of America

This book is printed on acid-free paper.

authorHOUSE®

DEDICATION

For Pat, who colors my world every day.

ACKNOWLEDGEMENT

Although I write alone, my work is shared effort.
I am grateful for the watercolors by Pat Morgan,
my wife and partner in life.

I am also thankful for my editor and friend, Jeanne Sutton,
who touched each poem with a firm, but insightful hand.

TABLE OF CONTENTS

WATERCOLORS

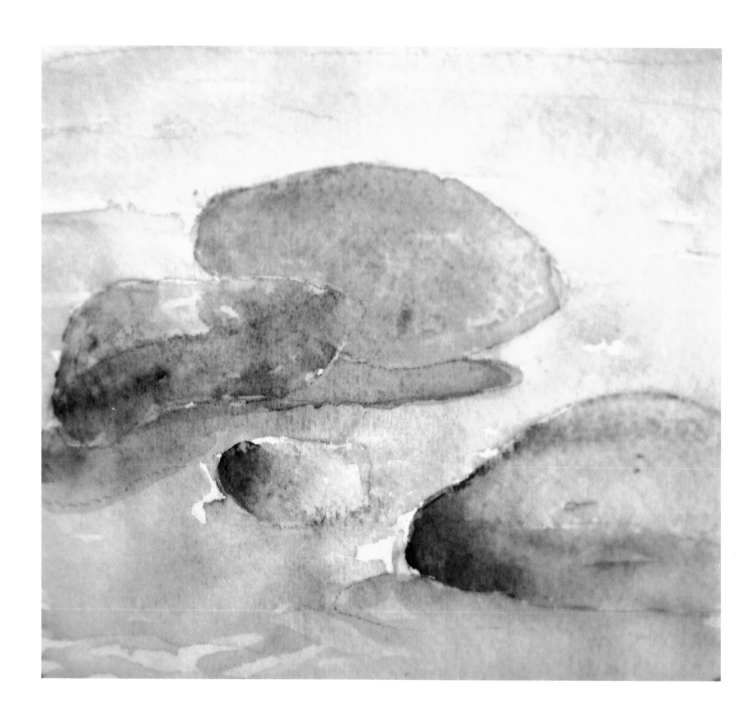

I AM SEA GLASS

You ask
Who I am:
I tell you
I am
Sea glass
Noxzema blue
Edges worn smooth
One corner
Jagged despite
Erosion
Dangerous
Dark and
Translucent
Mostly unknowable
More artifact
Than treasure.
Surviving.

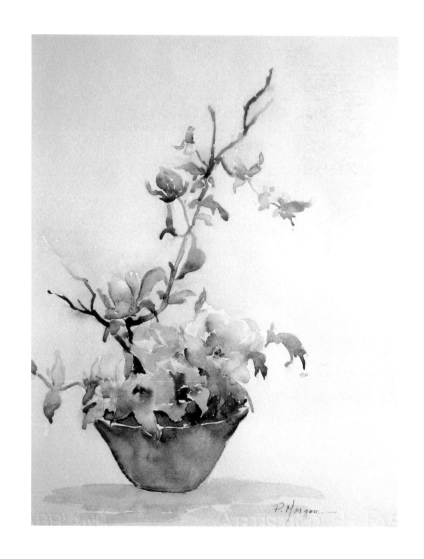

PRUNING POETRY

Be ruthless
Editing is
A heartless
Task.

Poems live not
By their wits
But by
Their words.

Don't use
Twenty
When eighteen
Will do.

Expel
Extraneous words
Until only
Heart remains.

THE BLACK FUNERAL DRESS

He starts across the street
Notebook pressed securely under his arm
Anxious to reach the other side
His mind six steps ahead of him.

She's a beauty barely old enough to drive
With a smile that seems to smile
Texting her mother about a black dress
She wants for Saturday night.

Sunlight and street sounds
Fill his senses
He has no time to savor them now
Maybe later.

The street in front of her appears empty
That was six lines of text ago
She hears a thud, looks up
Sees nothing unusual, drives on.

He feels ever so tired
Then nothing
Crossing the street
Is no longer important.

AN ASTRONOMER'S LOVE

She was a brilliant sunburst
Doubling the daylight.
His binary partner star
Circling him forever.
A splendid supernova
Expanding his universe.
A blue-white twinkle
In his heavenly sky.
The night she drove away,
He could still see her
in the distance.

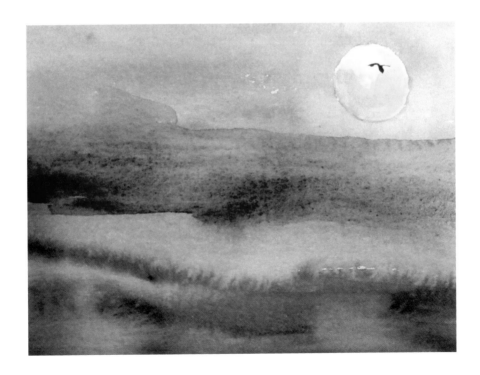

LIFE ON A LINE

I live beside a two-lane line
Dividing ocean from bay,
Linking Holgate to Lighthouse,
Parting yesterday from today.

I live on an upscale sandbar
Where my summer's loud and long.
Winter's solitary and quiet
With winds chillingly strong.

I live near the deep water,
Tireless waves slam the shore.
The line of tracks I leave in the sand
Last an hour, but no more.

I live most happily by the sea
Though I've seen sun and storm
I know my winters will be cold,
But my summers will be warm.

THE FOURTH BLOW

The sixth lesson
That taught me to survive
Wasn't any deeper
Than the previous five.

The fifth knock
That opened the door
Wasn't any louder
Than the previous four.

The fourth blow
That split the tree
Wasn't any harder
Than the previous three.

The third stone
That twinkled like new
Wasn't more precious
Than the previous two.

The second effort
That got the job done
Wasn't any greater
Than the previous one.

This last stanza
That needed to be said
Wasn't profounder than
Those already read.

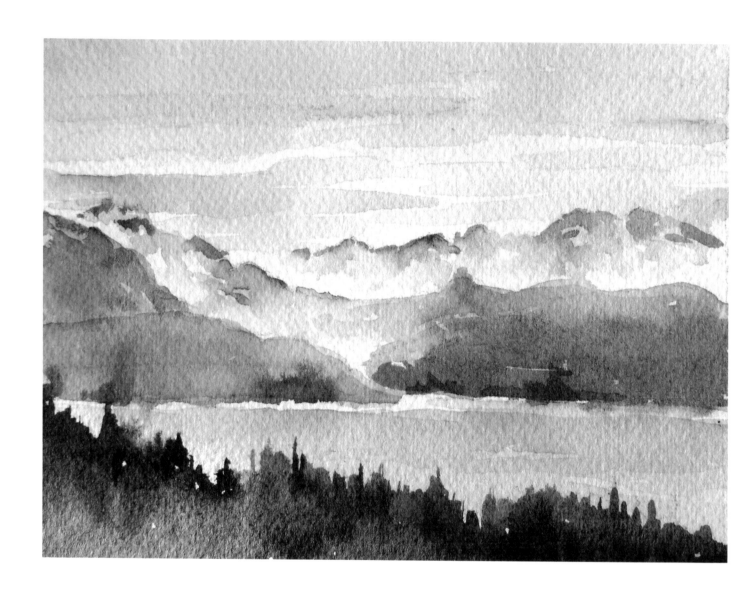

ENVY RUINS EVERYTHING

Ocean envies land
Striking it wave after wave
Washing it away
Resorting to tsunami
To soak it miles in.

Land envies mountain
Shaking it to its core
Quaking it till it falls
Loving each avalanche
It can cause.

Mountain envies sky
Blocking the light
Channeling the wind
Creating rain on one side
Desert on the other.

Sky envies ocean
Blowing hard over it
Whipping up whitecaps
Making unwilling waves
Crash against the rocks.

Ocean, Land,
Mountain, Sky
Were perfect
Before there was envy;
Envy ruined everything.

DUST

I am only dust trying to be a man
All I can do is the best I can.

I Am Only Dust trying to be a man
Sometimes I fought, sometimes I ran.

I Am Only Dust Trying To Be A Man
When I loved and lost, I loved again.

I AM ONLY DUST TRYING TO BE A MAN
I asked for help and I was given a hand.

I am only dust trying to be a man…

FLEAS AND FLIES

Do fleas fly
Without saying goodbye,
Or
Do flies flee
Depending on their bravery?

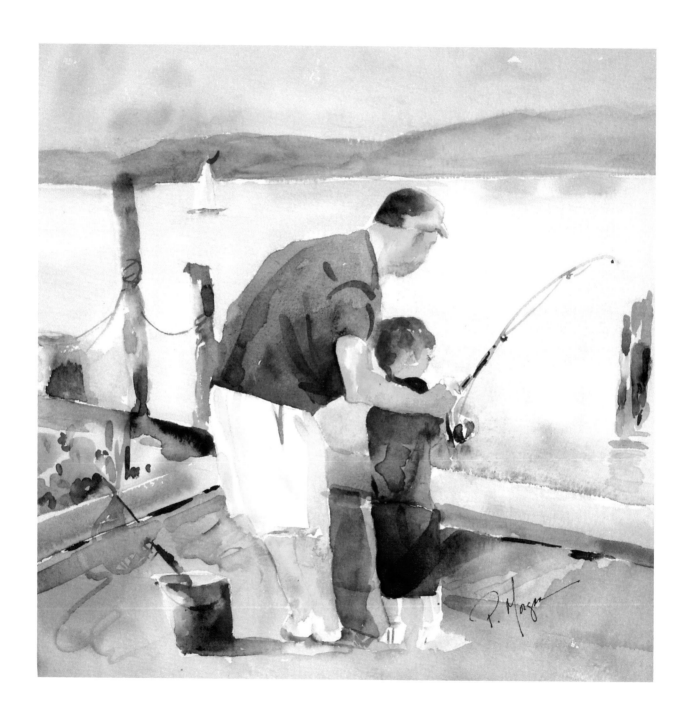

16

THE FISHING LESSON

The first time my Dad took me fishing
We brought a bag of worms.
He selected a big, fat one for his hook,
A small one for mine. I didn't mind.
He saw I was reluctant to pierce
My worm with my hook. Without a word
He took them from me. I didn't mind.
I was anxious and pulled the line before he was done.
The hook caught his finger,
Blood beaded up. He didn't yell at me.
After an hour he suggested we leave. I didn't mind.
He hadn't caught any fish.
I only caught his finger.
He didn't mind.

SIX DECADES DOWN, FOUR TO GO

I wear a tanned beret
With thin grey hair over the ears.
My body has scratches and dents
Like an abandoned '57 Dodge.
I hear only half of what is said to me
Even less, if you ask my wife.

I'm up early, tired by noon
In bed before ten.
I sleep with dreams I don't understand
They bubble up
From an unsettled past.

I'm not done driving that Dodge,
Still hungry for more meat and
More precious time,
Time in the sun.

UP

Life
Is like
An ant
Crawl-
ing up
A stone
Wall
And
Even if
It can't
It doesn't
Fear
The
Fall

TWO BE OR NOT TWO BE

Conflict goes on in each of us.
Too complicated for consistency
Too incomplete to be predictable
We each have one voice and
At least two opinions.
Now we see red, later it's blue.
We're not homogenized enough
To be single minded
More like Hamlet and the Mad Hatter
Woven into one homemade fabric.
It is a miracle we can live with ourselves,
All of them.

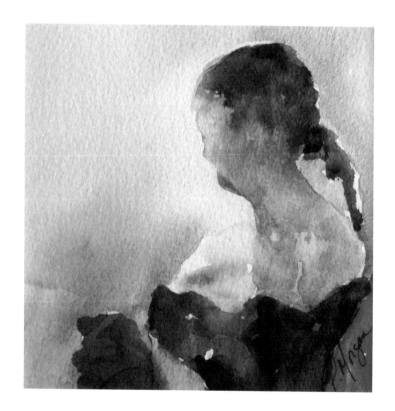

WATER'S SO SMART

Water's
So smart
Flowing
Downhill
Never
Thinking
Twice
Of doing
Otherwise.

I think
I know
What's
Right,
Only
To find
Myself
Pursuing
Compromise.

CRAB CLAW

I was in a terrible mood
As I walked the waterline along the beach.
Cynthia broke up with me last night
Claimed I was running away
Unwilling to face our problem.
So I left and drove to the shore.
I was alone in pain watching waves and
Crushing discarded shells as I walked.

My eye caught a splash of color,
A crab's claw without the crab.
Transfixed, I felt the awful pain it had caused
As it brought its catch to its mouth.
I scooped the claw into a clam shell,
Brought its beautiful blue arm and red pincers
Back to my rented room and placed it
On the night table next to the phone and lamp.

I moped through the rest of the day falling asleep
After finishing a silver bottle of tequila.
Sleep offered little relief from my pain.
Consciousness seemed far away when I first heard the tapping.
Tap, tap, tap
Like something striking the lamp base
Growing louder and louder until
I opened my eyes and turned on the light.

The claw sat in the shell. Motionless.
I stared at it. I waited.
Tap the lamp base one more time.
It did not move.
The message light was blinking.
Cynthia. She wanted to hear my voice.
At 2 a.m. I called her back.
Could she come to the shore so we could talk?

How does one feel when sunlight finds a crack
In the clouds and lights the ground?
I whispered "yes," then silently started to cry.
At dawn, waiting for her by the water,
Watching the waves,
I took the blue and red crab claw
With its painful pincers
and threw it back into the sea
Where it belonged.
It no longer interested me.

LIFE IN THREE ACTS
....AN OUTLINE....

Like a good play
A fully realized life
Has three acts,
Each loosely thirty years.
A premature closing or unfulfilled act
Makes the play a tragedy, but most
Are dramas sprinkled with comedy.

ACT I - LEARNING

Early on there's much to take in:
The sweetness of your mother's milk,
The others who touch you,
The noises around you,
Getting your way.
Just when you think
You've gained control,
An army of demanding teachers
With grade books calculating,
Tell you what's best for you.
Your rebellion lasts years.
Your character grows
A face of its own.
You think you're done learning,
You're not.

ACT II - BUILDING

Your sandcastles
Become real,
Commitments last years,
Not nights,
You marry or not
Have children or not
Trust love or not.
You chase a career,
Charge up the nearest hill,
Fall down the other side,
Look for a new hill,
Repeat the process.
Over time
Youthful energy erodes.
With experience and clarity
You've become content
To hike up the next hill
Where you take time
To appreciate the view.
You build a life,
Block on block,
Good or not,
It's your life.

ACT III - RESOLVING

In this final third of your life
You see where you've been
And are no longer going.
Outwardly generous,
You graciously share answers
As you suffer with questions,
Unanswered questions:
Did you love enough,
Do enough, give enough?
Yes…Maybe not.
There's still time?
Yes…Maybe not.
You and your glasses
Grow thicker in the middle;
Your doctors grow younger.
Above the stage door
An exit sign glares at you,
But you're not ready to step off stage.
Still seeking solid answers
To ethereal questions
You drill down until
You are out of bit.
With all you've lived through
You realize, maybe, an answer,
A resolve: Stop asking.
It's late. Now all you want is
To be standing
As the curtain falls
And the lights go out.

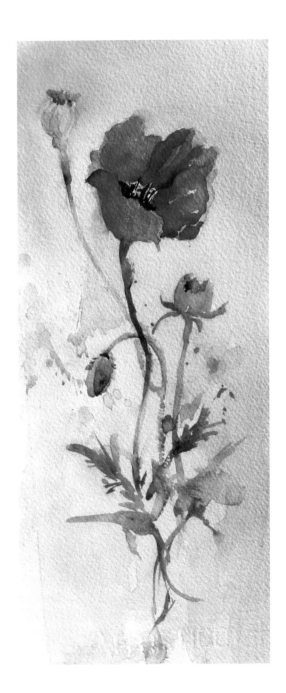

THE DOOR WAS ALWAYS OPEN

We were strangers;
They shunned,
Enslaved or expelled us.

We were outsiders;
They stole our homes,
Burned our books and scrolls.

They turned our ancestors
And grandparents
Into ash and dust.

Full of fear, they didn't know
They could not slay
Our hearts and souls.

Driven, we took with us
Our love of learning, laughter
And connection to God.

Our ways required
No luggage. They came along
Unnoticed.

POISON AND POISE
FOR GIRLS AND BOYS

Arrogance
Insolence
Living in the
Past tense

Counting cents
Taking offence
Doing what
Makes no sense.

Tolerance
Horse sense
Living in the
Present tense

Silence
Repentance
Accepting
Consequence.

Poison
To poise
For girls
And boys.

GOD SOUNDS

Wind bruising the trees,
Forcing them to sway
Making muscular music
Of symphonic strength.

Rain striking the roof,
Us safe in our bed
Warm and dry
Deep under the quilt.

The voice of my wife,
My life partner
Whispering she misses me
When I am away.

Our baby's crying
Showing her distress,
My knowing what to do
Gives us all relief.

Those not listening
Get no God sounds.
Souls without ears
Surely hear them best.

FOREVER DAD

I did not know him
The night I was conceived
Nor did I know him
The morning I first
breathed.

I did not know him
The day I became a man
Though I thought I did
Too smug to understand.

I did not know him
The evening he died
Absent most of the time
I hadn't even tried.

I did not know him
Though now I'm his age
Lost to me his dreams
Forever empty his page.

ARROGANT EGO

Elephant sized and
Big as Noah's ark,
Blocks out the sun
Keeps you in the dark.

In your Midas game
Manna falls for your sake,
Bank vaults full of riches
Are there for you to take.

Humility withers,
Ego's dry as dust,
Contentment can't survive
Eclipsed by mammoth lust.

Think I am here for you?
That is how it should be?
You may find, in the end,
You, friend, are here for me.

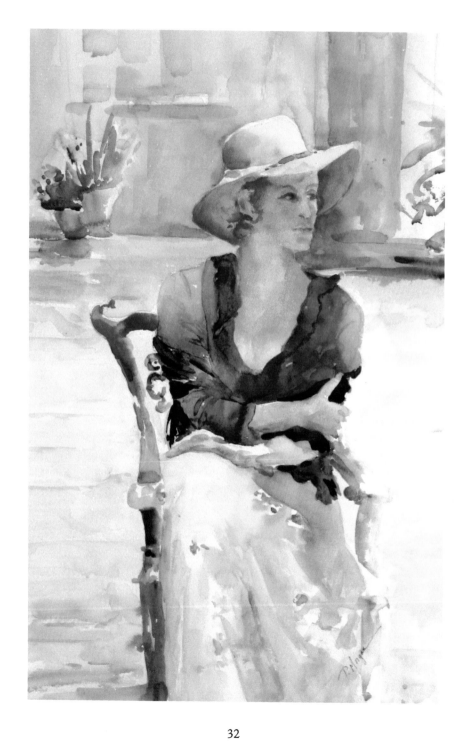

SISTER – I HAVE SOMETHING TO SAY

Sister with the bruised cheek, you
Did not stumble, but came too close.
If you dare get close again,
Again the blows will fall.

When I walk the beach
The dark stain of earlier waves
Guides me how near I dare go
Without getting wet.

Sometimes a rogue wave
Slaps the shore. Exceeds
What came before. Either I leap,
Or my feet get a soaking.

After days of calm, his rage
Will return aimed at you
And lest you dart, you may not
Survive the beating.

You are a loyal wife,
Humble but blind,
Ever more precious than
Your relationship with him.

The waves may have no say
Striking the sand.
Sister, you are not held to him
By gravity. Time to leap.

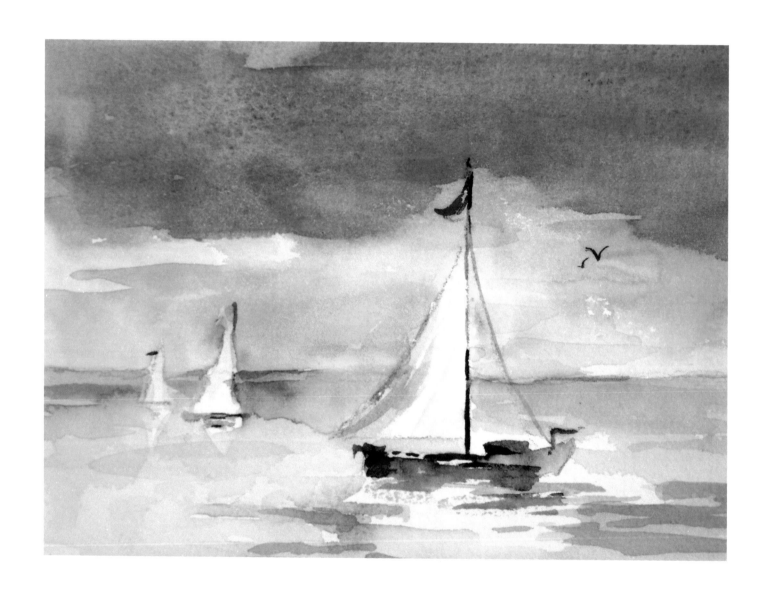

SAILBOAT MATH

I learned my geometry
From a sailboat. Try
Seeing what I saw:
The mainsail, a right triangle,
3 sides and a 90 degree angle,
The mast, a vertical,
The boom, a horizontal,
Met and married
Perpendicularly
Ever after.
A straight line ran
From top of the mast
To tip of the bow
Forming a hypotenuse,
The longest side
Of a right triangle.
Pythagoras probably
Would have enjoyed
The geometry scene
Watching a sailboat
Cross the horizon.

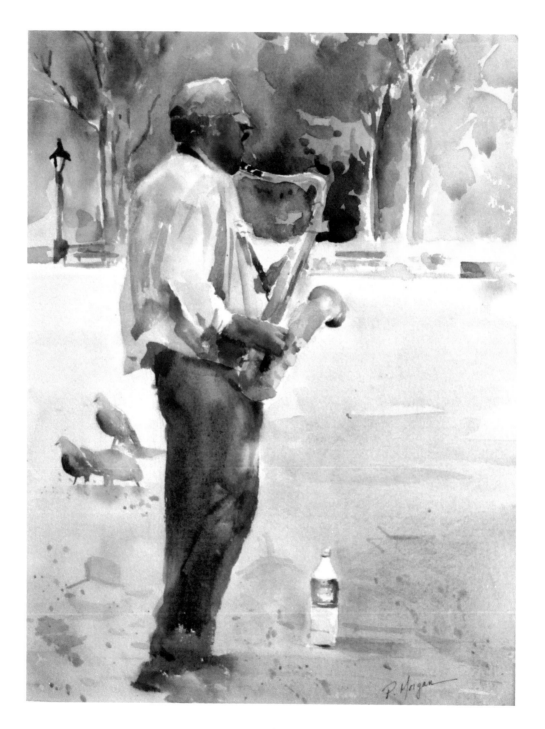

36

PAINTERS RESTAURANT OASIS
CORNWALL-ON-HUDSON, NY

Surrounded
By anonymous noise
Chattering patrons
Gossiping regulars
Jazz from the City
I settle in, comfortable
As though home.
They keep the lights low
Even on a cloudy day
My mind
Slows to dim.
Coffee in a sailor's mug
Arrives at my table
As I sit down alone
With room for six.
Sal greets me by name.
Without offering a menu
He takes my order
It's always the same.
I return day after day
To read, write, eat
And nourish my soul.
They know me here.

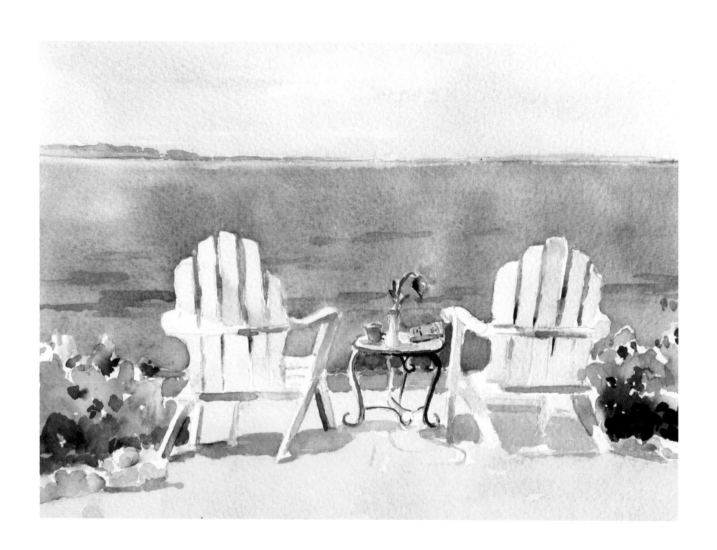

GROW OLD
WITH ME

Will you grow
Old with me?
Live quietly
By the sea?
Raise flowers,
And sip tea,
While I write
And rewrite
My poetry?

When the sun's
Above the horizon
A crack,
We'll lie
A bit longer
Belly to back,
Without a care
For the things
We lack,
Wealthy
In our wordless
Love pact.

ELEPHANT

There must be a reason
The giant, hulking elephant
Stands so silently
With aching shoulders
And gray, sunken eyes.

Has he seen too much
From his lofty view
Above the tall grass?
Maybe he's grown tired
Of recalling times
He fought to survive
Or fled for the sake
Of another tomorrow.

Now he is weary and mostly
Glad to be ignored.
But then on rare occasion
A young male approaches him
And by sheer proximity tries
To absorb his solitary strength.

Our giant from an age erased
Stands indifferent and still;
Closes his eyes.

MOTHER RUSSIA

From deep in my marrow
With her merciless winter and
Frozen unyielding ground
Unable to harbor deep roots,
She cries, but I'll never call her home.

My Russian grandparents must have
Laughed lovingly with raw cheeks
Protecting a warm spot in their hearts
Thinking of their children, else
They never would have made love.

My American parents never spoke
Of a motherland, so I was silent too.
Their parents' frigid past failed to melt
Leaving an unexplained thirst.
No stories of survival survived.

Yet, I am most certain they are there
In my soul's DNA. At the symphony
When the strings strike a minor chord
Or the horns blow a dissonant sound,
I respond beyond reason.

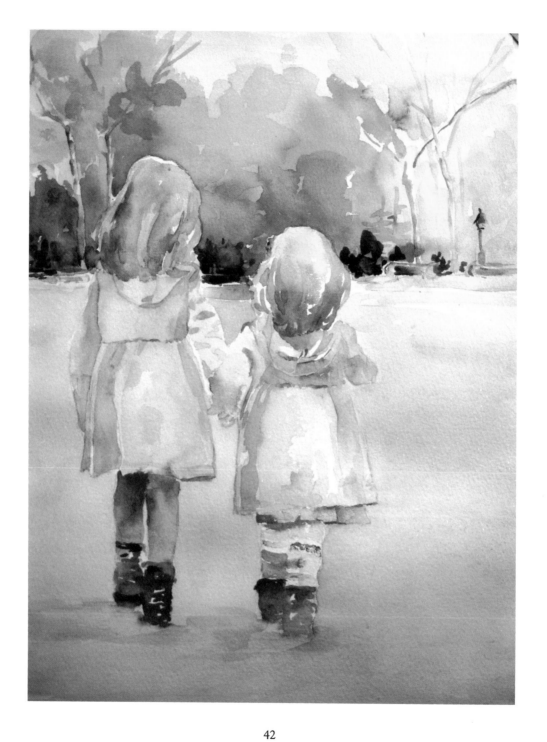

INHERITANCE

I'm pained
I placed
My rock
In your shoe
Not realizing
It'd become
An enduring part
Of you.
While
Raising you
I was living my
Imperfect life.
I realize now
My ways
Cut deep
As a knife.
Like a fish
Is unaware of water,
I was oblivious
To my will.
Today
Through your inheritance
You're living
With it still.
I've given you
Worthwhile gifts,
Along with them
Came my stone.
Forgive me
It's your life
Work hard
Make it your own.

RATIONALIZATION

After all my
Rationalizing
Analyzing
Self despising,
I reluctantly
Concede I am wrong.

Next time
I hope this realization
Unappealing sensation
Ego obliteration,
Won't take me
So long.

MISSING

It's January 10th.
My father would have been
Ninety-two
Had not he died
Twenty-two years ago.
How wonderful
It would have been
To have had him with me
These last few decades.
The two of us could have taken
Long, slow walks with
Laconic talks and
Even if he said but a few things –
Imagine what
They might have been.
But for me today
His unsaid words
Linger.
I long
To know them.

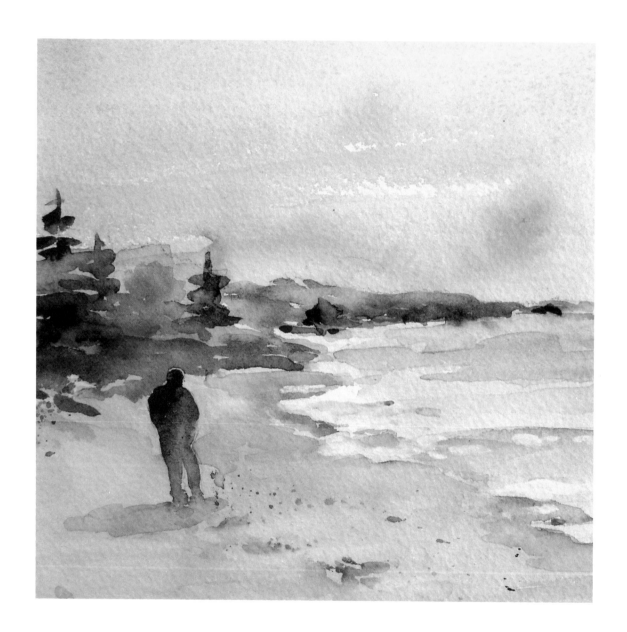

MORNING MEDITATION

I'd be first on the beach
If not for the gulls
There before the sun
Feasting with zeal.

Tap, Tap, TAP
Crack. A hole.
Death intrudes
Without invitation.

To a crustacean
A gull's heart
Is as hard
As its beak.

The sun now
Five fingers above
The horizon
I'm late for breakfast.

Left behind
My footsteps pass
A seashell landfill
Without remorse.

ABOUT THE AUTHOR AND THE ARTIST

Richard Morgan grew up in Newburgh, a small city 60 miles north of Manhattan. He began writing poetry in high school, encouraged by a young, pretty English teacher he had a crush on. At SUNY-Albany, Richard was the lone physics major in the creative writing class where he found his professor's criticism, though not as gentle as his high school teacher's, accurate and needed. An educator himself for some 40 years, he retired to New Jersey's Long Beach Island with his wife Pat in 2009. Early mornings Richard walks alone with the waves and the gulls, collecting sea glass and shells and letting his mind wander while the island muse visits and inspires ideas for poems. He shares his "poetry by the slice" at *poetspizza.blogspot.com*.

I Am Sea Glass is an eclectic collection of his poetic pieces.

Everything about painting in watercolor is a joy for Pat Morgan: the work, the lessons, the struggles. Over the years, she has experimented with various techniques and styles, but she has always returned to the soft and dreamy quality of the brush stroke that captures just the essence of what is before her. When not painting or in her gardens, Pat enjoys teaching other painters, sharing her love of watercolor. Her watercolors can be seen at *patmorganart.com*.

CPSIA information can be obtained
at www.ICGtesting.com
228202LV00002B